Copyright © 2012 Jeanne Paglio

All rights reserved.

COPY PERMISSION: The written instructions, designs, patterns and projects in this publication are intended for the personal use of the reader and may be reproduced for that purpose only. Any other use, especially commercial use, is forbidden under law without the written permission of the copyright holder. Every effort has been made to ensure that all information in this book is accurate.

Layout by Hale Author Services

The 5 R's & Life...

Tangling is so much more than doodling. Doodling is great fun and has benefits, but tangling has been more beneficial for me than mere doodling. Whatever you decide to call it, by using this *mindful* art form, you can change the facets of your life.

As a life-long artisan, self-taught and then college trained, I was smitten with Sandy Steen Bartholomew's magazine article explaining and depicting the art of tangling. Taken with the beauty of her illustrations, I knew I had to learn this. I sought an instructor, took a class, and registered for certification as a Zentangle teacher. Certification, in any area, allows a person to feel comfortable when teaching. It shows students that training has taken place, but certification is by no means a college degree and should not be understood as such. Certification simply means there's been a significant degree of training that allows the instructor to show students the how and why of an art form and the theory behind it. The theory behind the *mindful* art of tangling is, in my estimation, what makes it so worthwhile.

With that theory in mind, I developed my own 5 R's to help everyone understand how tangling can benefit them. Take from it, as I have, what works for you. **I don't pretend to be a psychologist, or medical doctor in any way imaginable, I simply know what this art form has done for me, and I wish to share it with you in the hope that you may find it a help in your daily life.**

I've been down the dark alleys and dim tunnels of anxiety, self-doubt, anger and depression. Those pathways seemed so long and difficult to traverse, that I thought I'd never see the light of day, but I was wrong. While I struggled against the odds, without medication which I refused to take, I searched for a healthier life, a way to get better without medication, alcohol, or using food for comfort. While tangling doesn't resolve all my problems (health or otherwise), it helps me deal with them, makes me feel better, tangling relieves my anxiety, helps throw stress out the window and allows me to focus more on what's positive rather than negative. Tangling offers me a way to find solutions to those things prohibiting a good lifestyle. What effects me, effects those around me. I want my life to be happier, to carry a lighter weight on my shoulders, and I want a life where the sun shines and the dark alleyways stay at bay.

I don't promise that you'll derive the same benefits I have from tangling, but give it a try. You have nothing to lose and everything to gain. So, get ready to use the 5 R's of tangling to change your lifestyle, to find a more positive you, and to learn how treating yourself better is the first step in becoming healthier, both physically and mentally. YOU DESERVE IT!

The 5 R's

Relax ~ Reflect ~ Renew ~ Replenish ~ Reveal

Materials... Keep it simple!

Basically, all you need are a few supplies to get started. A black-ink pen, a #2 pencil, a blending stump, and a 3 1/2" square piece of paper.

The paper size is important since a regular sheet of paper is more daunting than a smaller sized one is. Compare the two. Place an 8 1/2" x 11" sheet of paper in front of you and one of 3 1/2" right next to it. When first starting out with tangling/doodling, I found the smaller paper worked better for me, and it still does, even though I have moved on to larger sizes. A traditional Zentangle square tile is a 3 1/2" piece of watercolor paper made specifically for tangling, however, any type of paper you wish to work on is fine. I often used Bristol paper that can be found in craft stores and comes in a pad, or even card stock will in a pinch.

The pen I used when I first began to tangle (and still use the most) is a Micron 01 pen manufactured by Sakura. They are found in art/craft stores and last a long time if properly cared for (like not leaving the cap off when not in use). A piece of advice...always hold the pen gently and press lightly for good ink flow. Using the pen in this way also allows the tip to stay in good shape. Pressing hard ruins the tip and the pen becomes useless.

The #2 pencil is fabulous and necessary for shading. (There's a whole page on shading and how to make your artwork pop off the page.) It's a regular pencil you've undoubtedly used throughout your school years. You know, those pencils with the yellow coating on them? Those are a #2. The number stands for the lead density.

A blending stump (properly known as a tortillion) is a tightly wound piece of paper that comes to a point at the end. It's used to smudge the graphite from your pencil to enhance the shading of designs so they pop and become more interesting. Once pencil lead (graphite) has been applied to the drawing, you'll use the blending stump point to pull the graphite from where it rests against the pen line and smooth it outward to allow the shade to take place. The works in this book have shading added to them using the graphite and blending stump to add interest for a finished appearance. When you doodle or tangle, it isn't important where you shade as long as it stays consistent. In other words, if you shade on a particular side, do all the same sides as you go. Here's an example:

Rudimentary

Crafted on a white background using a black-ink pen, (which sounds monotonous, but isn't), tangles begin with one mark which is then repeated. This repetition is where relaxation comes into play. The saying "Every journey begins with one step at a time" is exactly how tangling begins... one mark at a time. By concentrating on making marks with the pen and the feel of the pen in your hand, you begin to relax. A light grip on the pen is also necessary. The tighter the grip, the less apt you are to relax.

"There are no mistakes...only opportunities". When an OOPS moment occurs, turn it into an opportunity and move on. Who will know it was an OOPS other than you? NOBODY! That's the beauty of the process. There is no wrong way to tangle, just your way. There are many (over 110) tangles designed by Zentangle® art originators Rick Roberts and Maria Thomas (www.Zentangle.com) that have inspired the examples in this book and are also standing alone in single tangles consisting of one design only.

While you may enjoy color, as I do, color makes you think. You'll think about the color wheel, it involves mega decision making such as what color should be put where, whether it's complimentary or not and that sort of thing. Black on white involves, well...black on white. Stick with black on white for now and indulge yourself with color later on. This book is done in black on white to show how engaging and beautiful those two colors are.

I always recommend starting with black on white with pencil shading. That way, you become more relaxed, less inhibited and fearful, more productive and self-assured.

Relax—allow your mind and body to rest.
Think of 5 things that make you smile.
Allow your smile to make you happy.
With each pen stroke, you'll feel better and less stressed.

Now...let's get started!

Place a tile (3 1/2" piece of paper) before you. Using your pencil, place four dots on the paper, one in each corner. Now, connect those dots (still using the pencil).

The next step is to drop a string. (A string is a guide that allows you to separate sections on the tile in order to make multiple drawings. It's not a real string, but a penciled string in any curve, slope or angle. Don't fret over it, just start somewhere on one of the lines you formed when connecting the dots, and place a penciled string inside the box you've made. Set the pencil aside when you're done making a string.

Now you start using the pen and where the real fun begins. Smile...Breathe (3 deep breaths), relax your shoulders, your body and your mind. Throw out concerns, let the drawing be what it will.
Remember...There are No Mistakes...Only Possibilities!

Relax ~ Reflect ~ Renew ~ Replenish ~ Reveal

These are the 5 R's benefits I realize from tangling.
You can realize them, too!!!
As the saying goes..."It's a no-brainer!"

Relaxation

Find a spot to sit in, place a tile before you, add pencil dots and connection lines to the tile. Drop your string inside the lines using your pencil. Start tangling with the pen. Fill in any spaces around the design if you choose. Add some lines of shading to the tangle and smudge it with the blending stump. That is the beginning of the relaxation process of Zentangle.

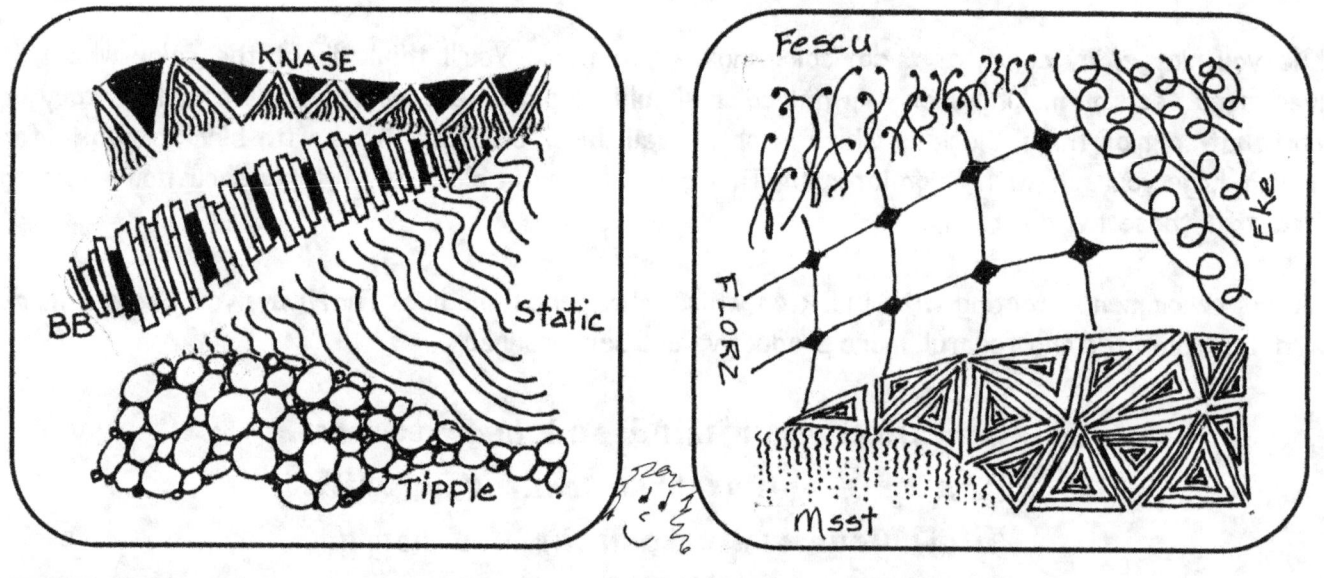

Benefit #2 ~ Reflect

Consider the paper, the pencil, the pen and the repetitive marks you are about to make or are making. Let your body relax, set your worries aside as you concentrate. Reflect on what is happening at this moment for lightness and tranquility to enter your life.

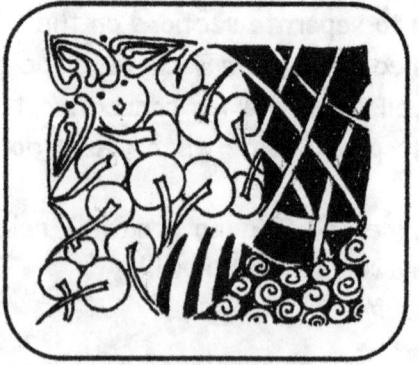 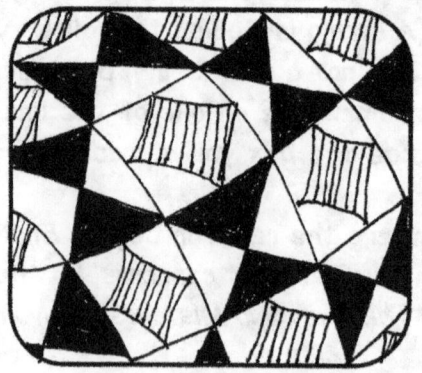 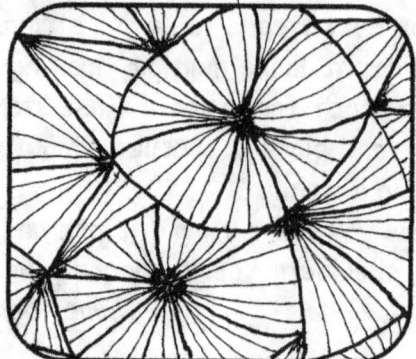

The pencil marks are a request, while pen marks are demands. One is a suggestion, the other is final. Use the pencil to place a dot in each corner of the tile. Then connect the dots and drop a string, again, using the pencil. All tangled designs are then done with the pen. Shade with the pencil, and smudge using the blending stump. See the numbered examples below.

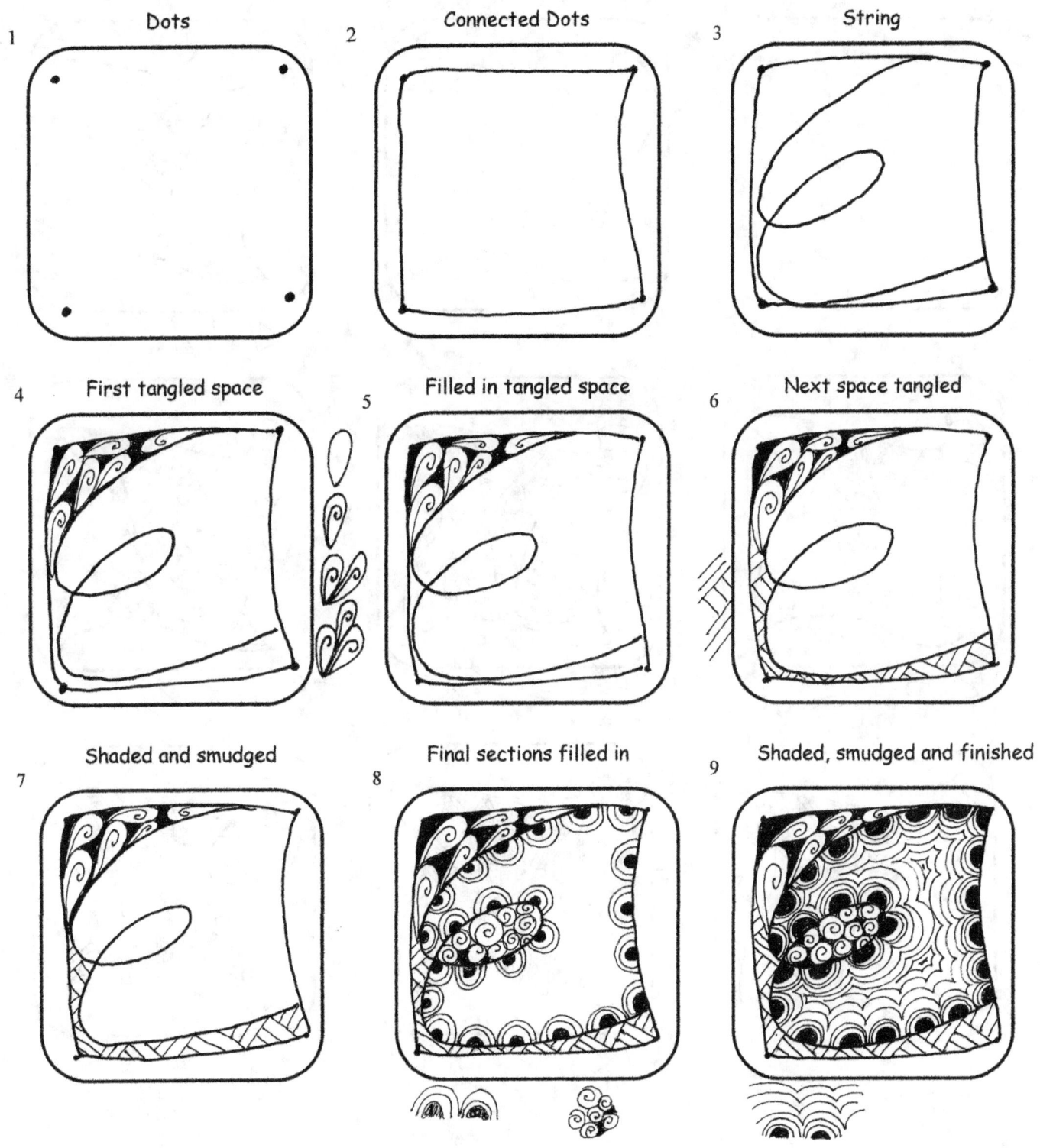

Concentration becomes easier with each tangled section. It is perfect for children and adults alike. **TIP: Hold the pen gently, use light pressure for increased ink flow. Relax for more control over the design and over yourself.

Tangle here and there, everywhere, and on everything. Shoes, old or new, t-shirts, umbrellas, book bags, carryalls, ceramic surfaces, wood, glass, tile, floor cloths, the possibilities are so numerous. Teachers use it in schools to help children unwind and develop more focus, while helping to handle the stresses of childhood and class time.

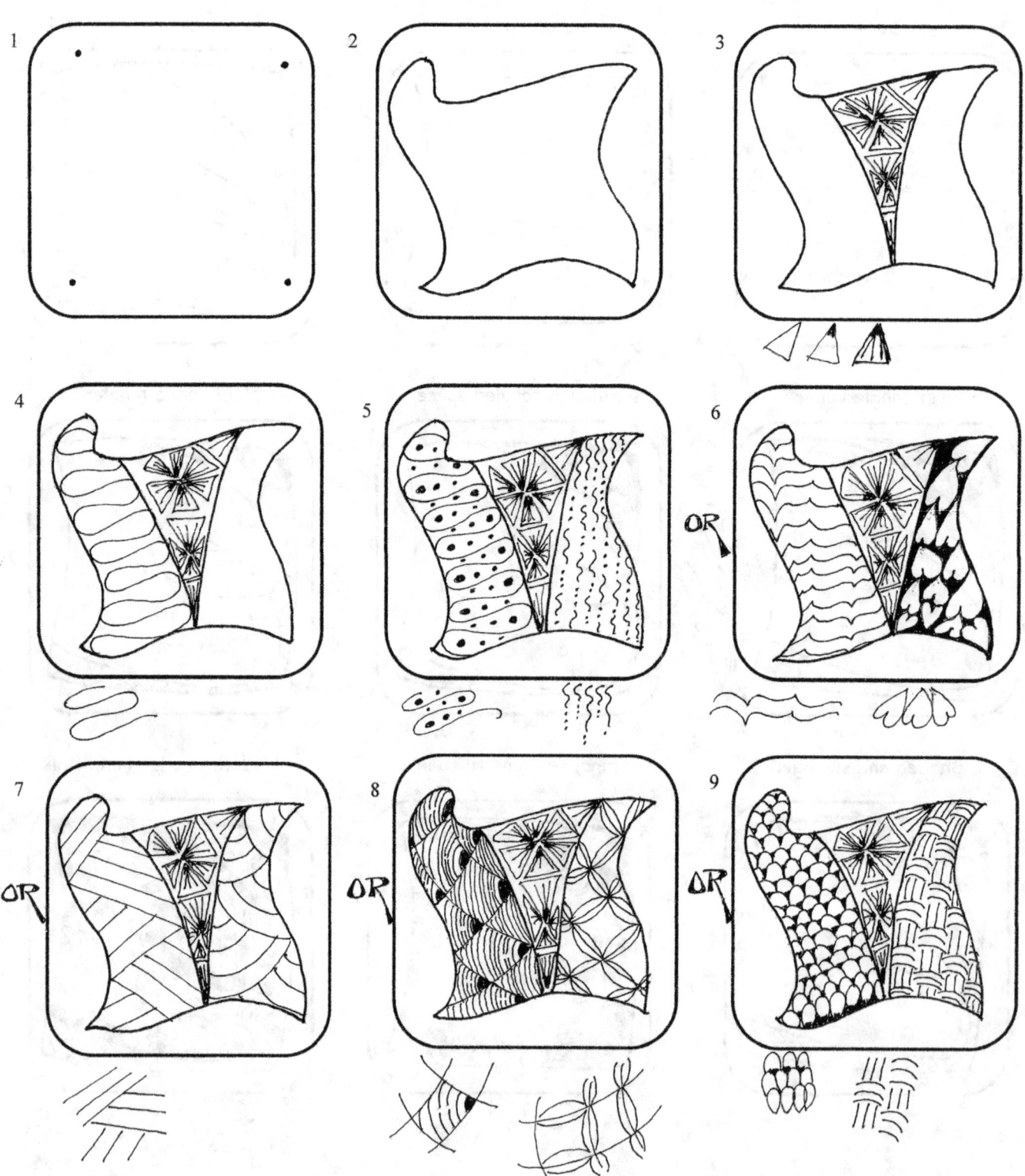

Start each day with a 5-10 minute tangle. Carry a tangling kit with you. It may come in handy when least expected. Assemble a kit for a friend or child.
Share your foray into the tangling world.

6.

Shade it ~ a little or a lot!

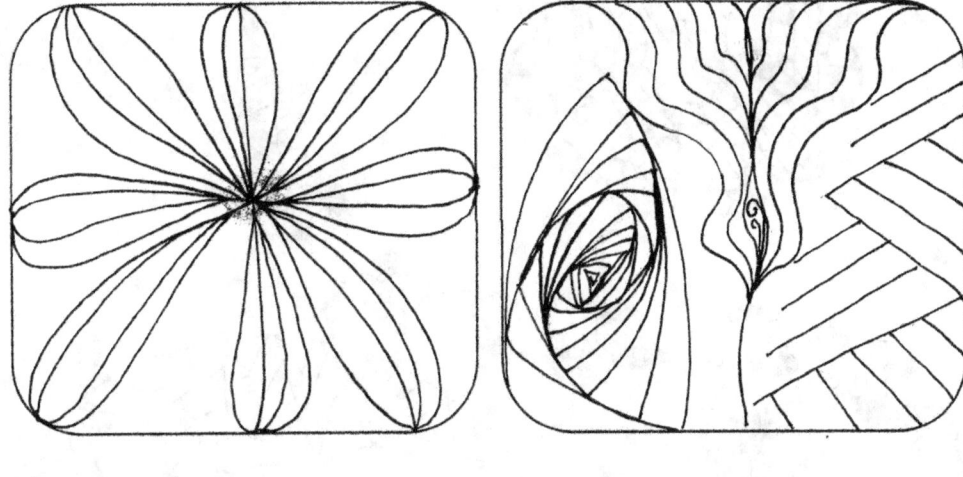

By adding the graphite to consistent specific areas, your eye will be drawn to it and travel the drawing. These few examples are simple in design and offer a look at how shading makes a difference. One drawing has no shading while the others are shaded for depth.

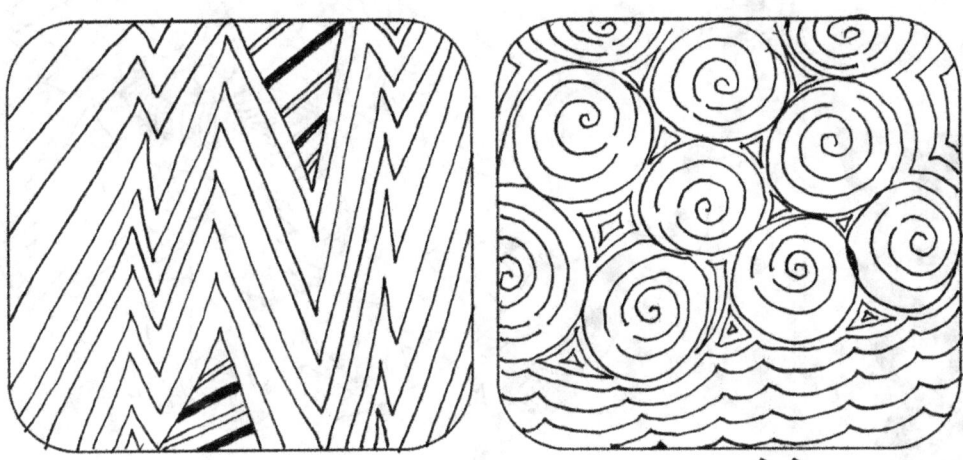

Get a feel for shading by using the pencil to place a soft lead line alongside the pen line. Then use the point of the blending stump to smooth the lead lines outward, causing the shadows to appear.

**Shadows appear as a light source strikes an object. A shadow changes as the light source (the sun, for instance) moves. In this art form, a stationary light source will cause a consistent shadow because it doesn't move. Graphite placement is always next to the pen line and smudged. It can be inside or outside an object, it's your choice.

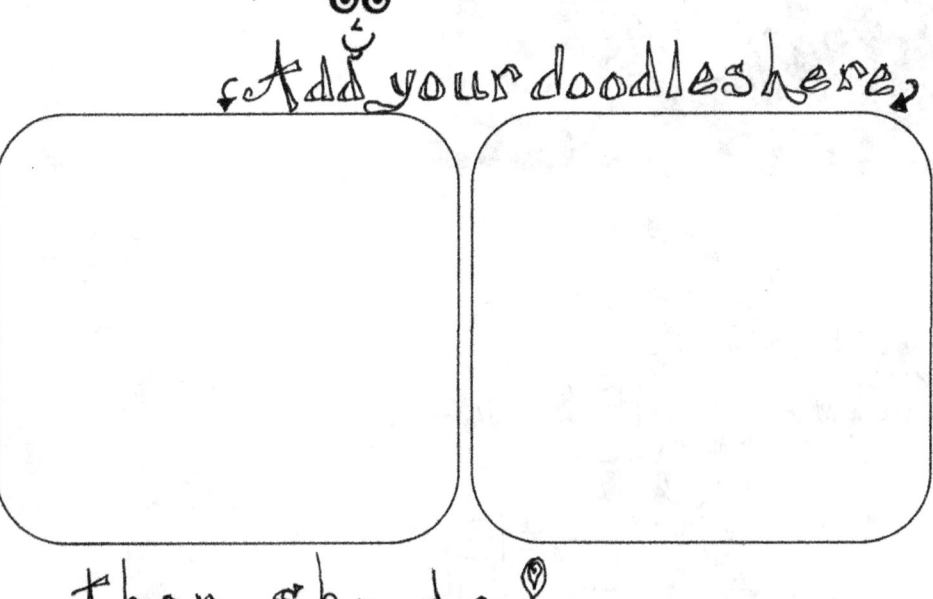

Add your doodles here

then shade!

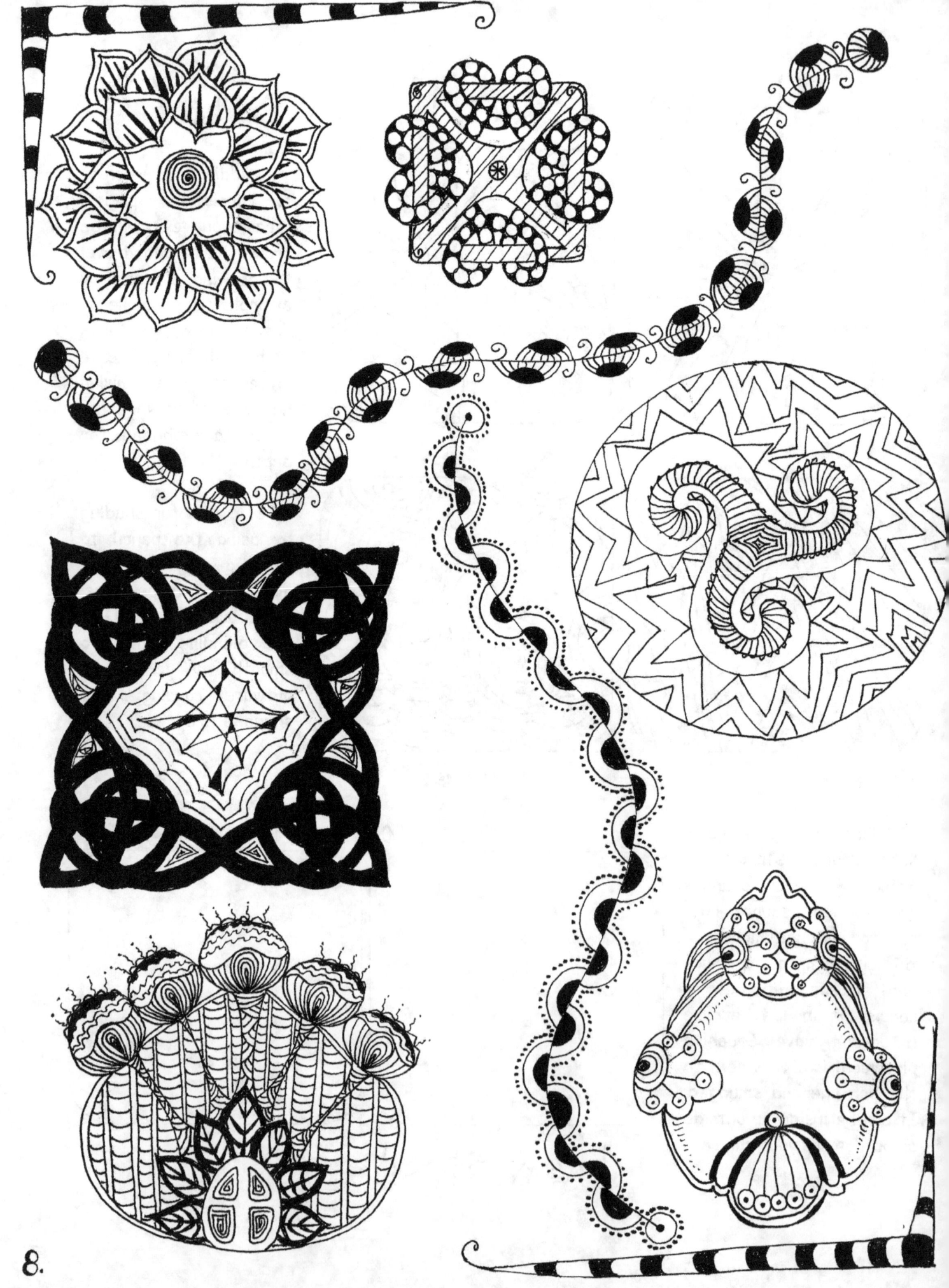

Tangles ~ Notes & Thoughts

No 2 tangles or doodles are the same. They don't have to be. Relax and breathe! That's the beauty of this art...

Strawberries
Blueberries
Oranges
Yum!

**Tangle for Mind, Body & Spirit
Find Joy in Tangling...**

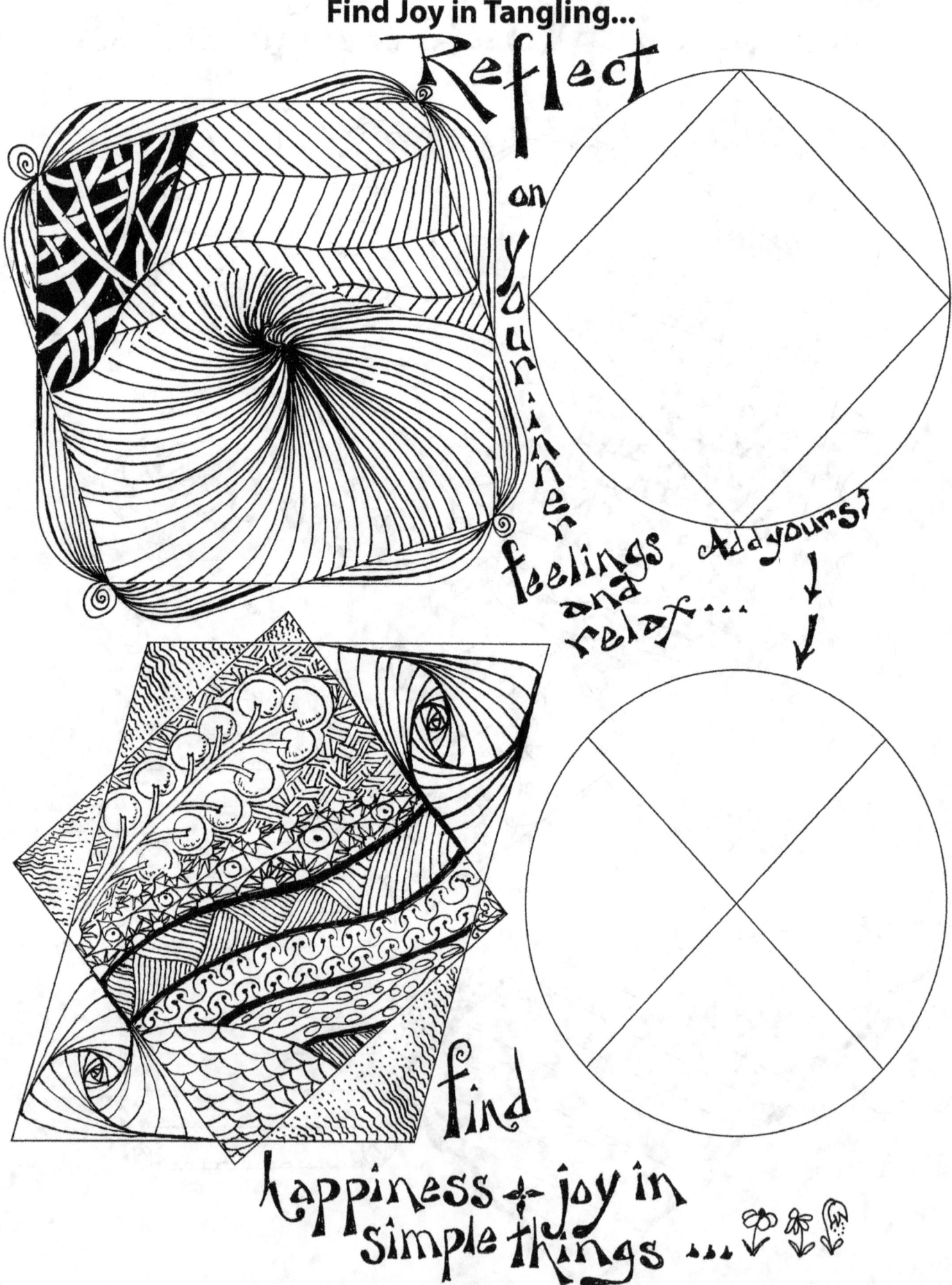

Reflect on your inner feelings and relax.... Add yours↓

find happiness & joy in simple things...

What's in it for You!

The joy found at the completion of each tangle makes the time spent worthwhile and beneficial...

to your health, focus, creativity, mindfulness, and

 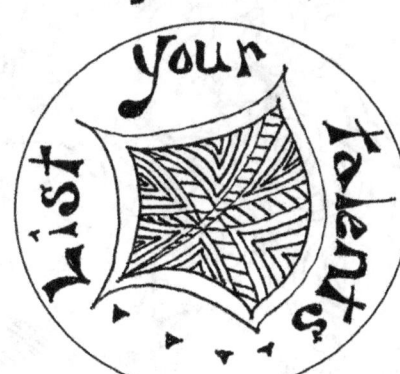

List your talents. Problems can be opportunities.

can increase self-worth!

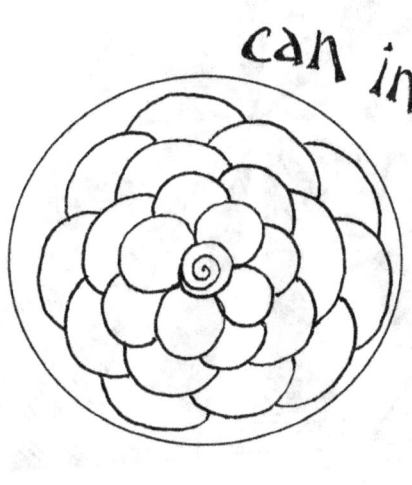 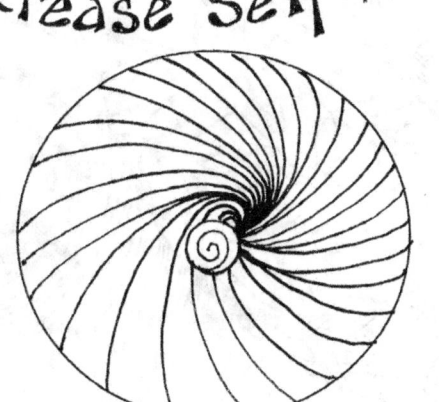 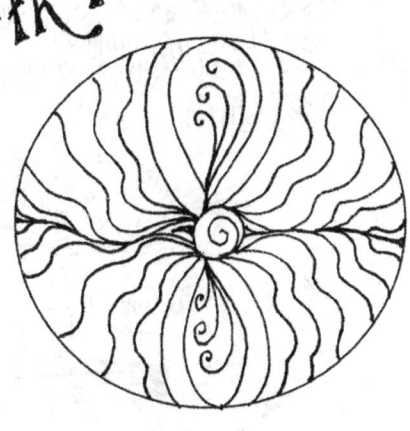

11.

Depression

This all too well known, and debilitating, health concern is real. We can deal with it by using tangling to help get through times when we feel so very down.

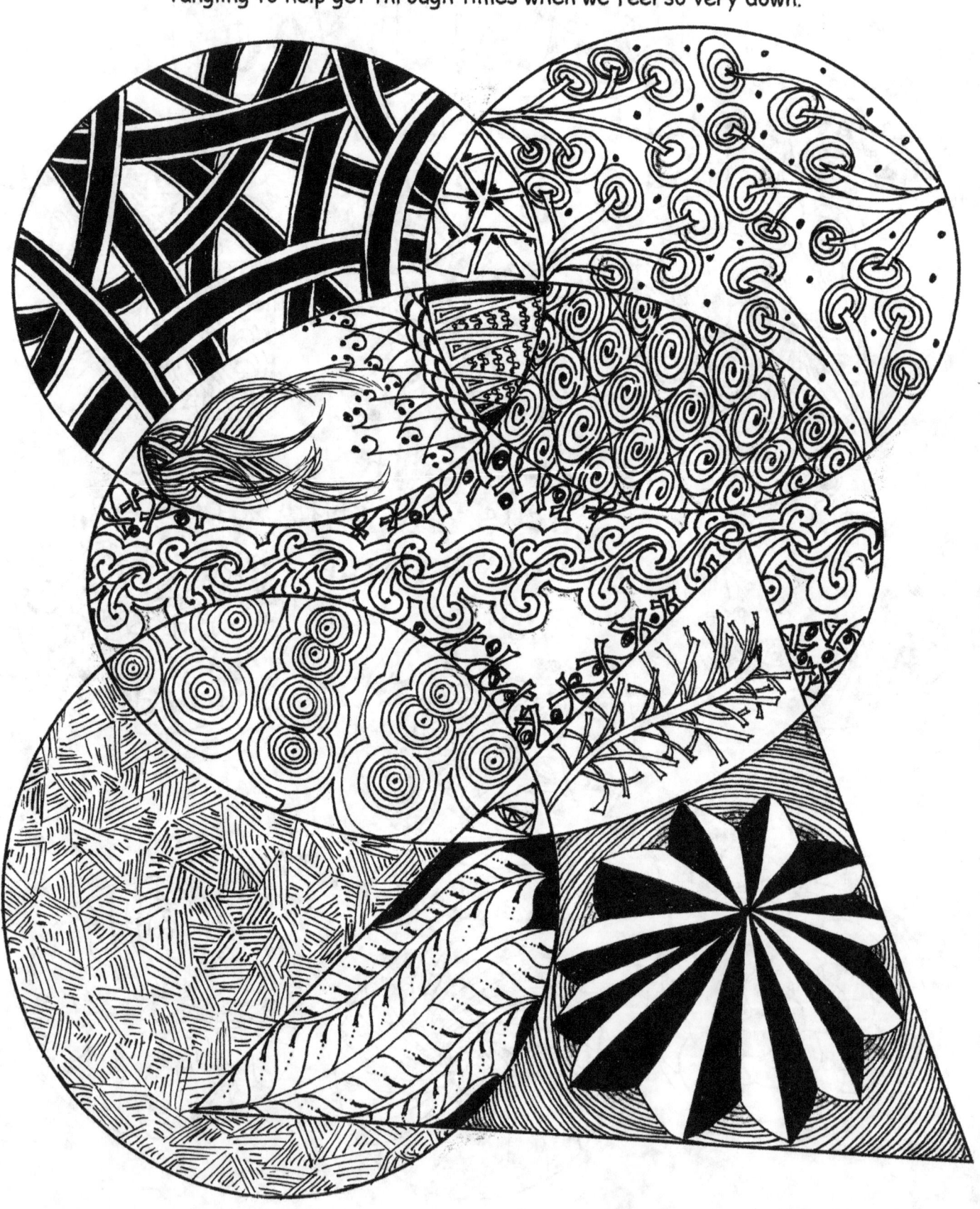

Begin to reward yourself with a journal to keep your thoughts & tangles together. What's important in tangling is the comfort and sense of accomplishment derived from the method. Overlap designs ~ stack them ~ coil them like rope. Fill tangles ~ utilize white space. (Add color for enhancement.) Be healthier ~ TANGLE

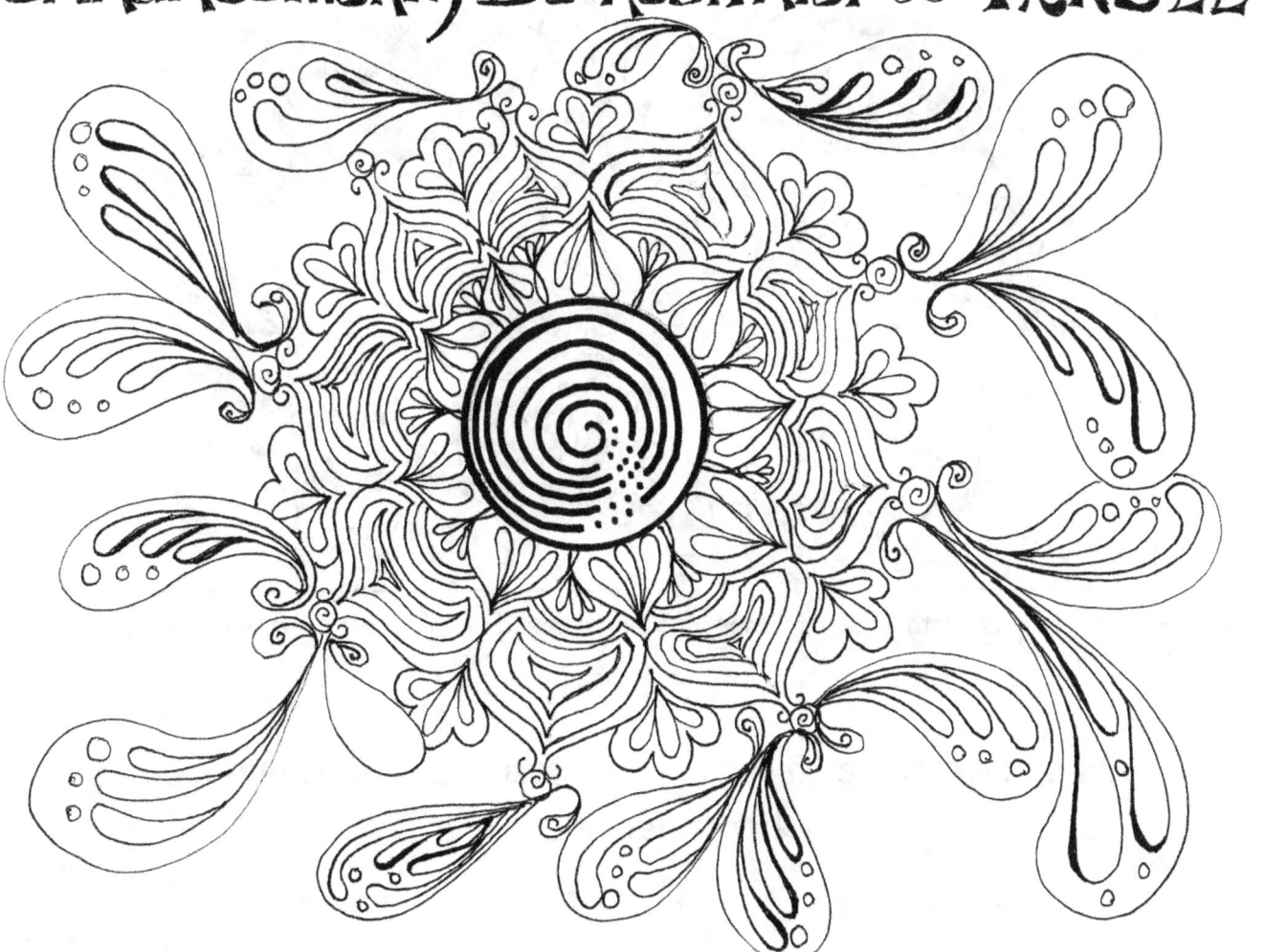

Food for Thought...

Awareness of dietary needs is a plus! Sweets are tasty, even though they hold no quality vitamin value, and they don't improve our health. Fresh fruits and vegetables contain nutrients essential to sound bodies and minds.

Eating well doesn't mean eliminating our favorite snacks. They can simply be eaten in moderation. If the ingredients used to make the sweet (listed on the package) don't tempt your taste buds, then like as not, you're better off not eating that treat.

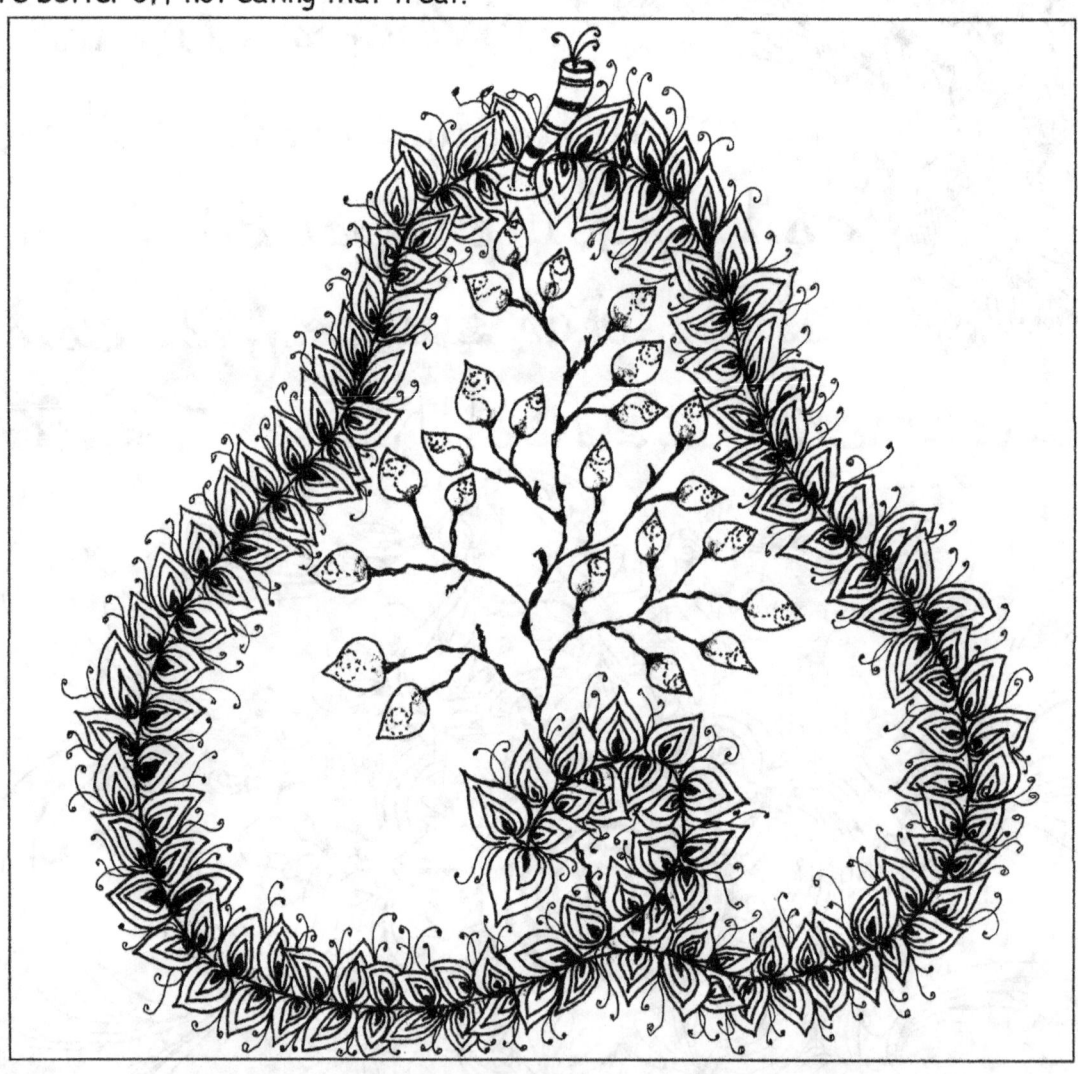

Starchy foods such as pasta, rice, potatoes, and white bread should be limited (not necessarily eliminated).

All foods and exercise taken in moderation sustains and maintains a healthier you!!!

Slow Down

Leave the fast-lane behind, learn to say "no", stop your feelings of guilt. Take a deep breath and relax. Live for the moment! If life becomes too complicated, the fun disappears.

Take Stock

Ours is a "must have, I want, instant gratification" society. It is fast paced, becoming more so, if we allow it to do so. Evaluate your life and lifestyle. What can be eliminated to lighten the present burdens bearing down, causing stress and pressure to build? Take time to list them, put them down according to the stress indicator. #1 as the least stress on up to #10 as the most stressful. From there, eliminate the lowest numbered stresses. Set goals to enjoy life more.

Tangle often & Smile

15.

Walk in the Sun

Tangling, to me, is like taking a walk in the sun. It's refreshing. I come away with feelings of accomplishment, increased focus, a sharpness of mind, and a sense of relaxation. Tangling time, however long or short, is a period that has helped clarify answers to a problem or issue bothering me. I feel lighter for having treated myself to tangle time. All in all, I'm better off for having done so. No matter what, I know I'm on the right track. My doctor, friends, work associates, and my family have all seen the difference in my attitude, health and my ability to get off the sofa and get moving.

I do take walks in the sun, not just through tangling, but real walks. Each step along the country road I live on reveals surprises that were absent the last time I took that route. I find plants and see birds and animals that I wouldn't normally find in my back yard. I come away inspired by nature. It's not just the artist in me, but a true appreciation for what surrounds me. If you aren't a country dweller, but live in the suburbs or in a city, find a good place to walk. The exercise and fresh air will do you no harm, will invigorate you and reveal new inspiration for your tangled doodles and your life.

Reflect on the good things in your life that make you happy, bring a smile to your face, and add joy to your being. For example, when a person smiles at another, the automatic response is to smile in return. A smile is a pleasant feeling, one that changes our appearance and makes us less formidable looking. People respond to facial expressions, body language and what we project. When we are sad, depressed, unhappy, people notice something is amiss. They might wonder where you are in life and how you got there. You're probably wondering the same thing about yourself.

You have an opportunity to improve your life just by smiling, using the 5 R's and creating a tangle everyday. It won't hurt and it's better than medication, (though I would never oppose your physician).

My students often express how well off they have become since tangling/doodling became part of their lifestyle. They handle their jobs better, say that their problems are solvable, and they have a positive outlook, along with more happiness and greater health. Tangling isn't the end all—be all, but it certainly can make a difference, if you allow it to do so.

Walk daily ~ stay as active as you can to stay healthy in mind & body!

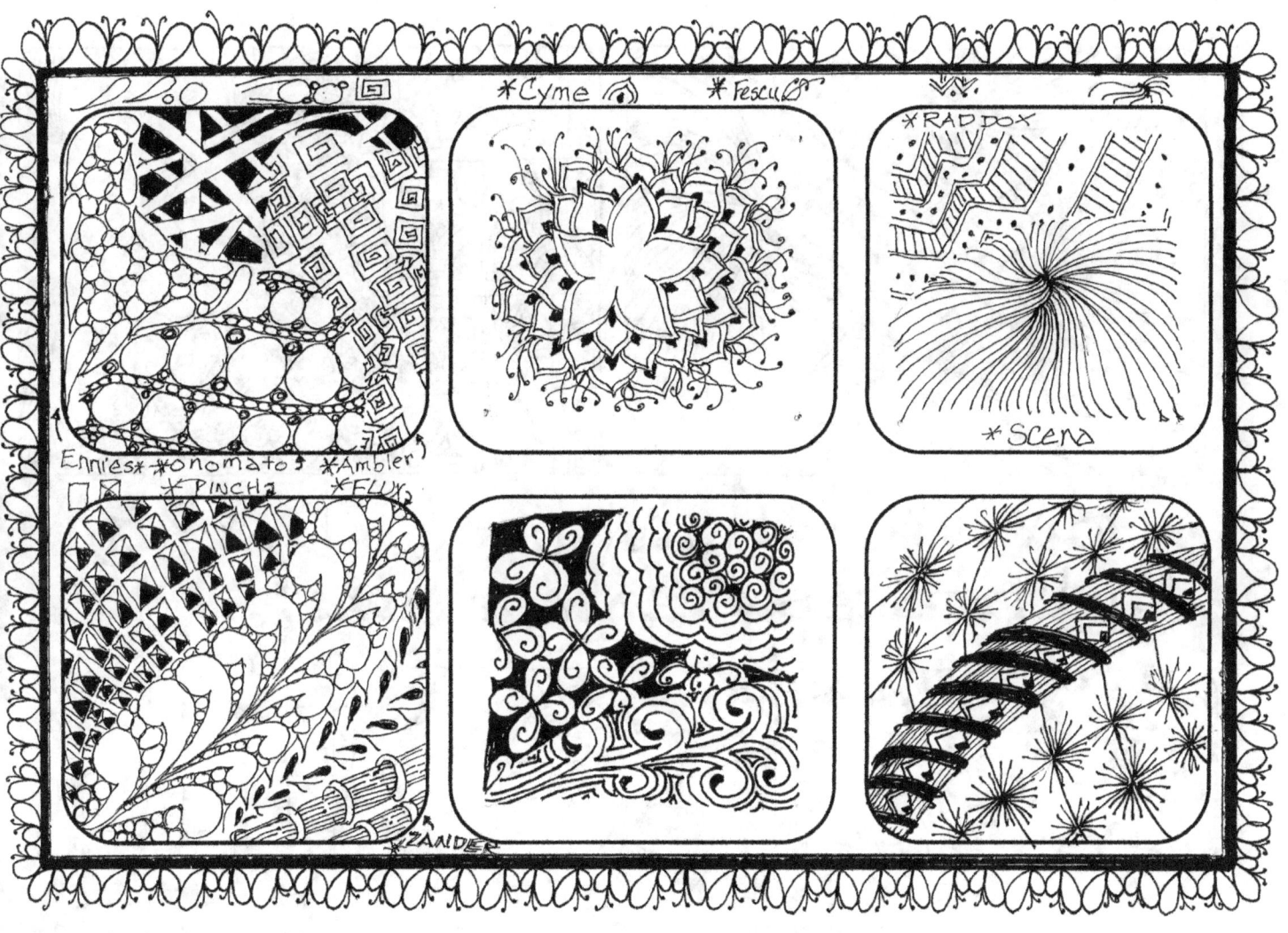

Eating foods rich in vitamins and full of nutrients adds to overall health and wellbeing. Fruit ~ Veggies ~ Fresh or frozen juice ~ Limit sweets, snacks, starchy foods.

Live Well ... Relax ... Tangle Daily

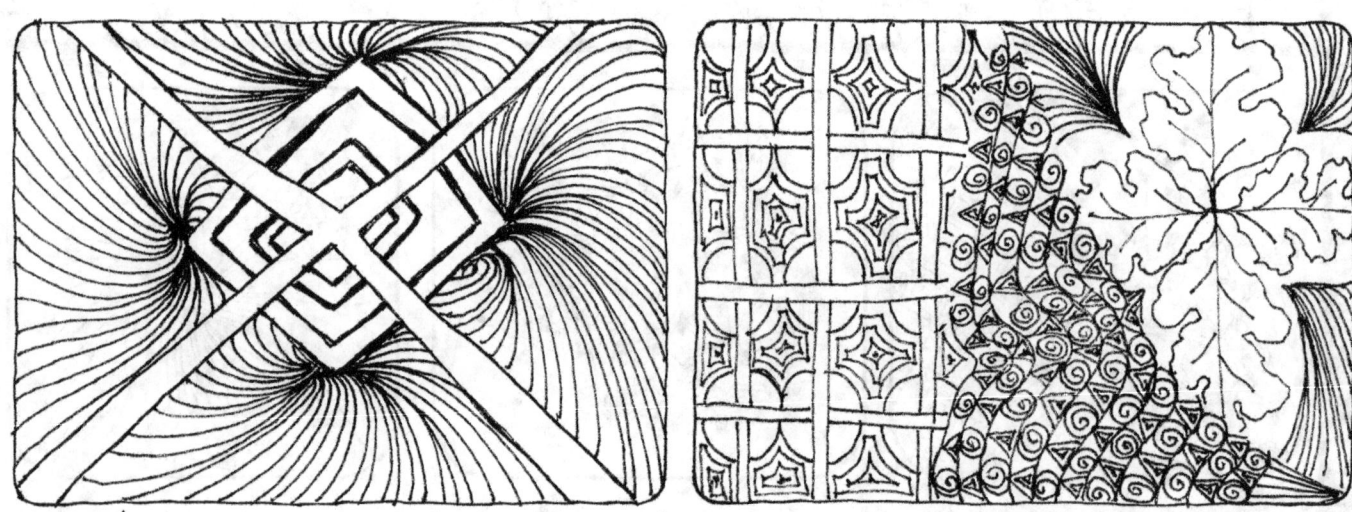

Thin lines ~ Thick lines ~ Dark & Light spaces create interest...

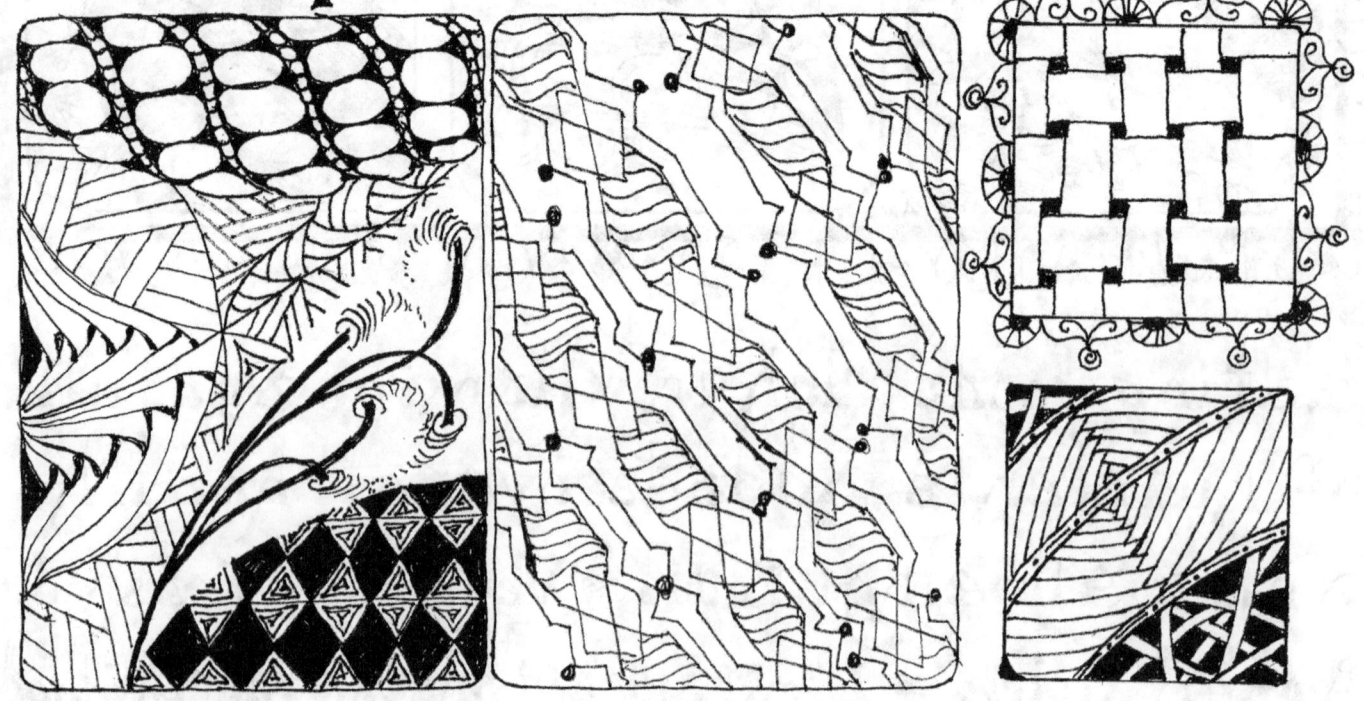

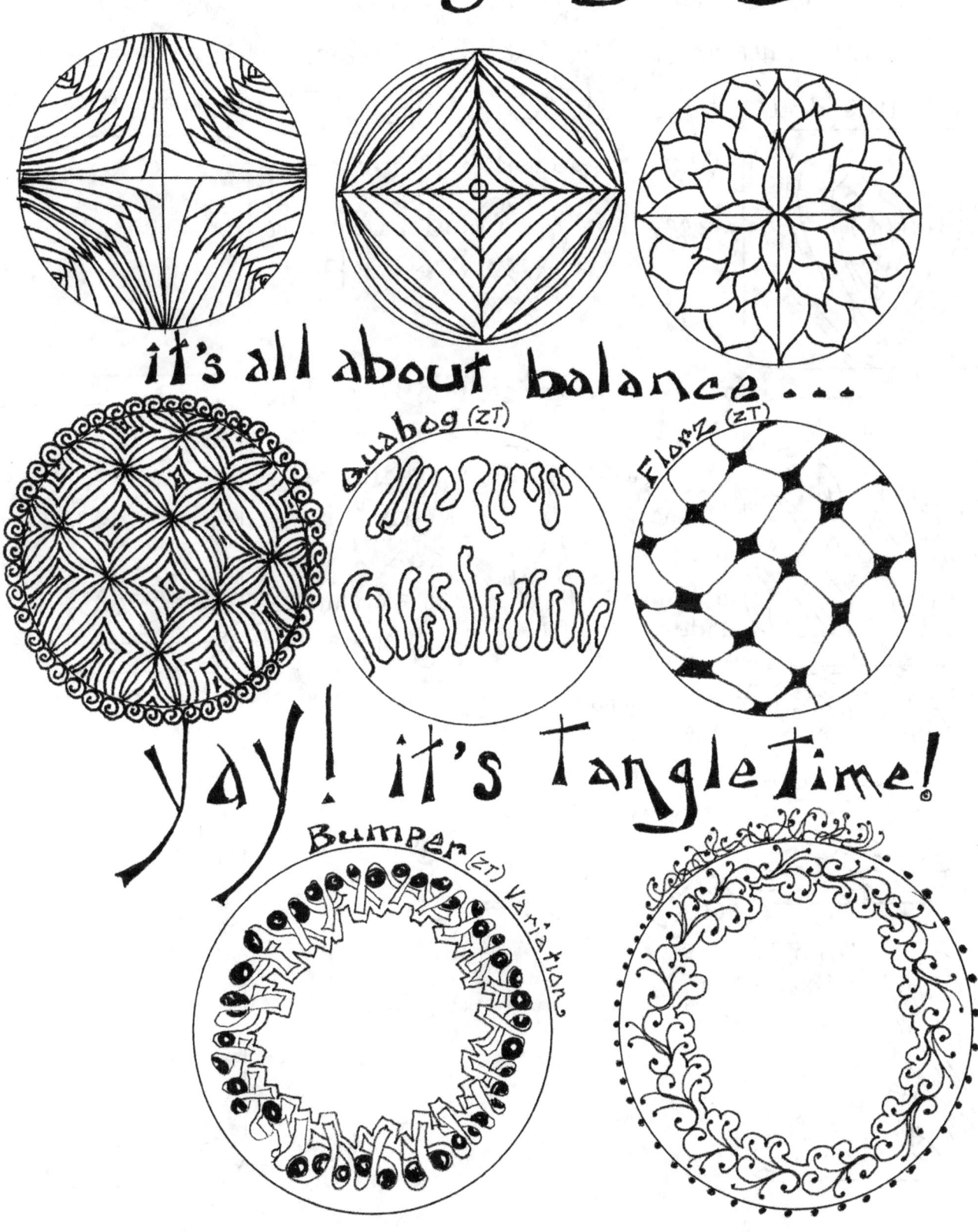

Ex * Samples ... & more

Here, you'll find simple, single tangled squares that can be used to build your own design by including some of each sample. Construct yours by de-structing mine. *Don't forget to shade.

Mooka - Begin with a line and keep going... until there's no space left.

Grass - Long tendrils flowing in waves. Begin with one main grass. Tuck others under one another.

Place yours in these boxes. Make this a goal! There are no mistakes, only opportunities...

Heart-tarts - connect hearts, put diamonds in the spaces. Outline. repeat outline. shade.

All 3 designs combined and shaded

20.

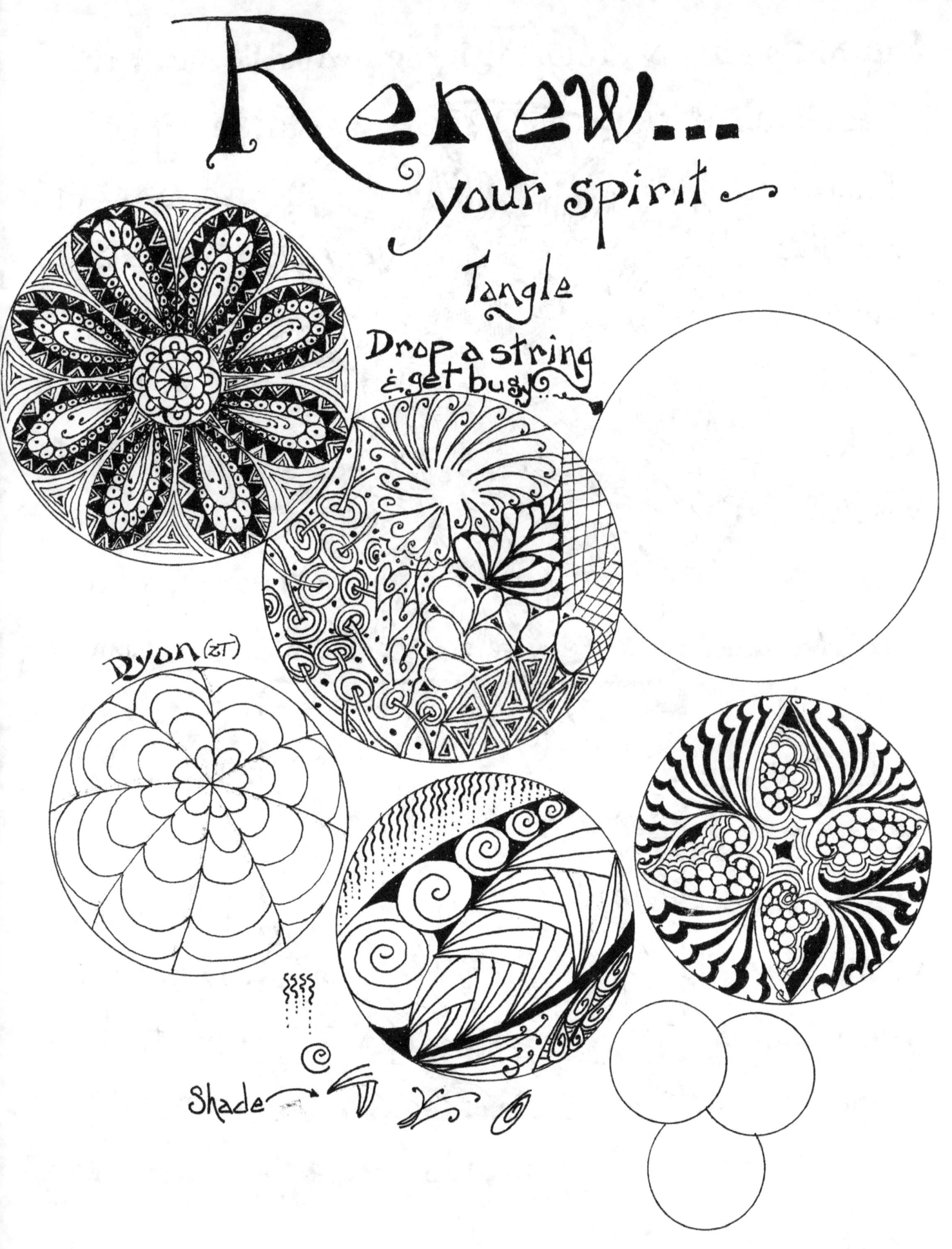

Sunni Brown, a visual thinker and public speaker, speaks about the positive effects of doodling and making repetitive marks. She has found the end result is an increase in the ability to concentrate. Her guest spot was recorded on CNN's Idea Series. www.SunniBrown.com

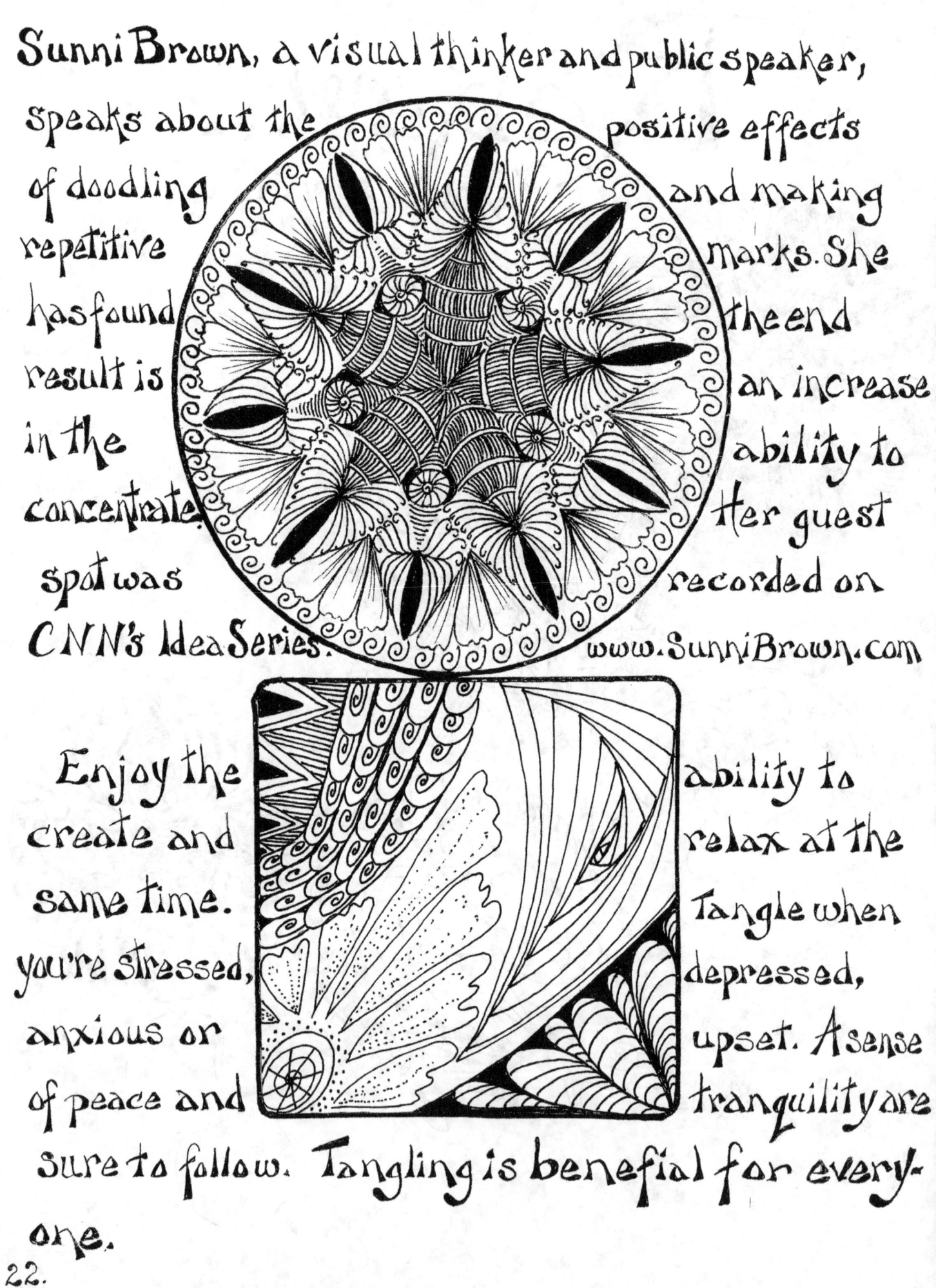

Enjoy the ability to create and relax at the same time. Tangle when you're stressed, depressed, anxious or upset. A sense of peace and tranquility are sure to follow. Tangling is benefial for everyone.

22.

Replenish...
your energy

Physical Wellness | Psychological Wellness & Emotion

Spiritual Wellness | Social Wellness

Tangle these Circles

23.

I replenish my...
creative and life energy by adding daily tangles to my schedule. Whether I tangle briefly or for long periods of time, I continue to replenish that which needs to be.

You replenish by...

Everyone develops their own style of tangling to help fill their needs and to suit their own purposes...

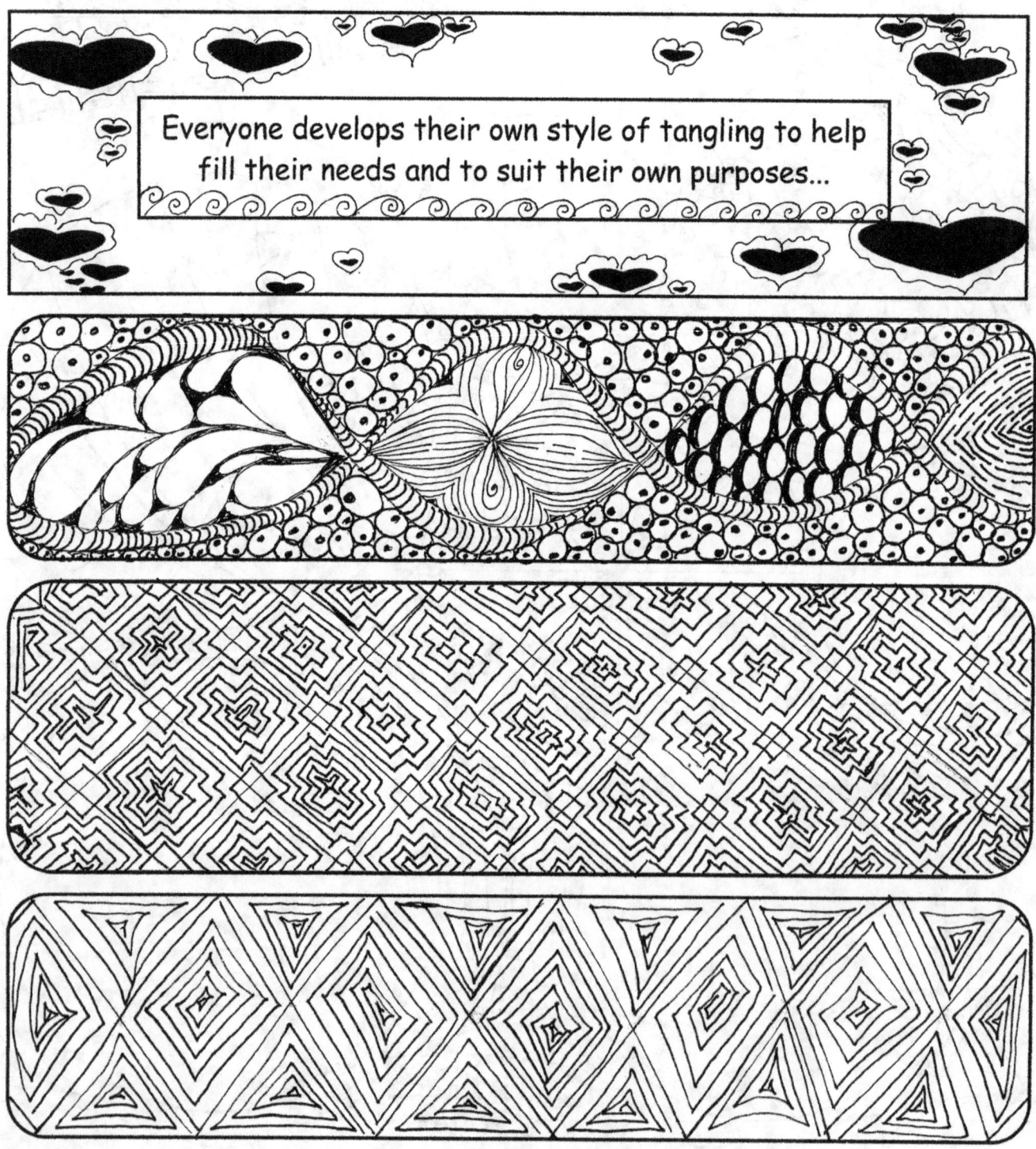

Exercise your creativity.
Calm your mind, sooth your spirit, and renew your energy.

A tangle a day can help build a new and stronger you.

♡ Tangling can become addictive!

Sleep well... tangle before your bedtime...

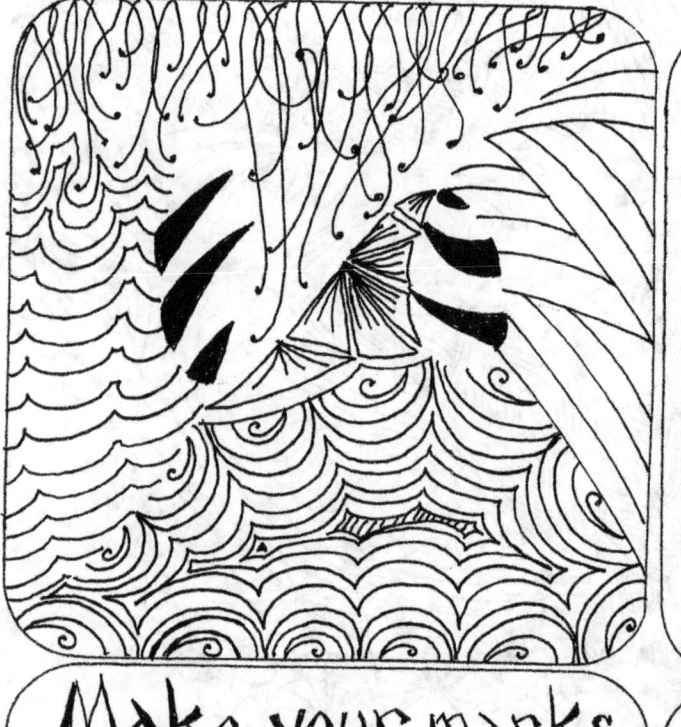

Repetition is key. Making repetitious marks aids in the relaxation process. Increased focus occurs when we are in a relaxed state of being...

Make your marks

Shade with a pencil & smudge

A sampling of mindful marks:

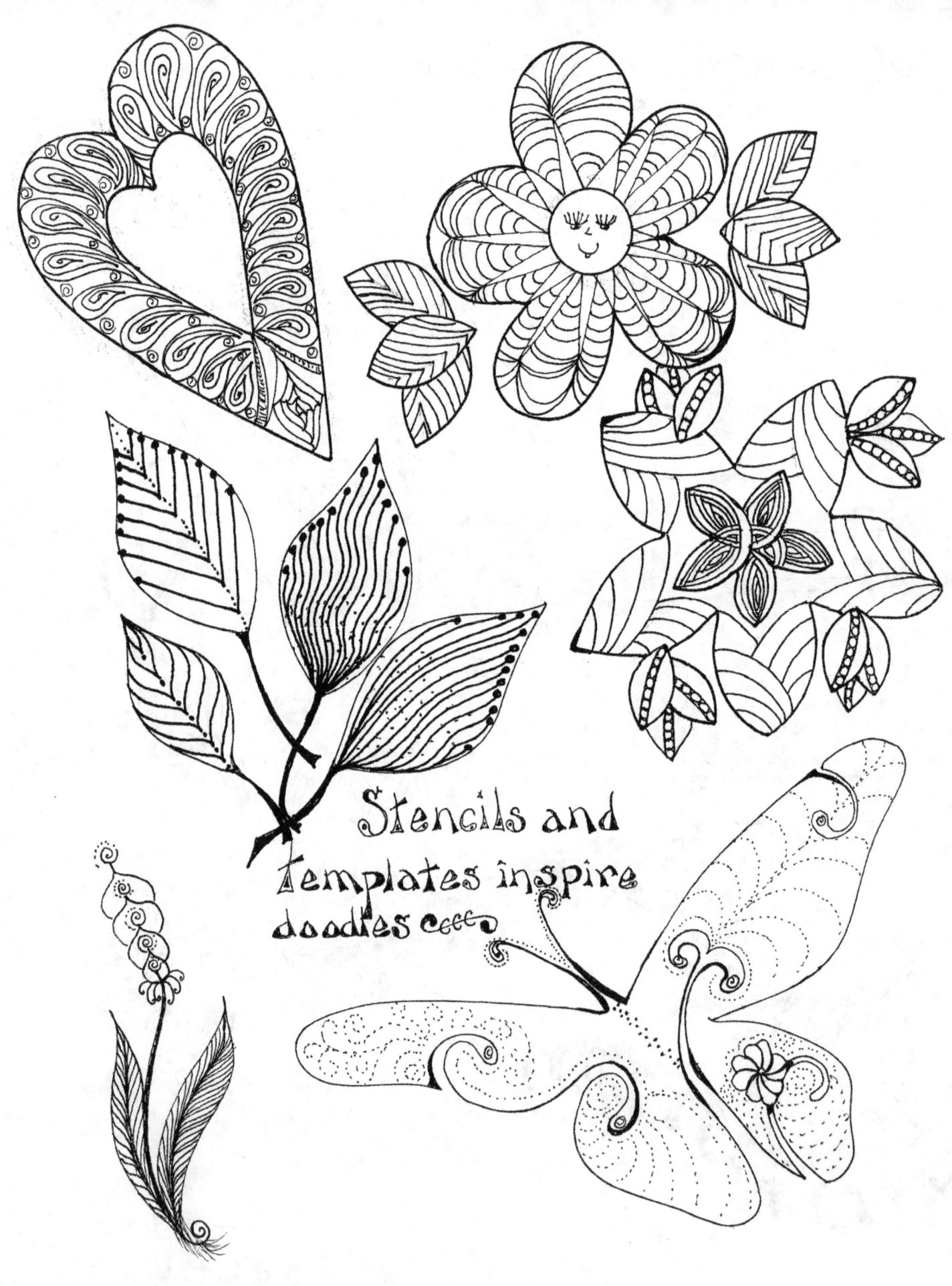

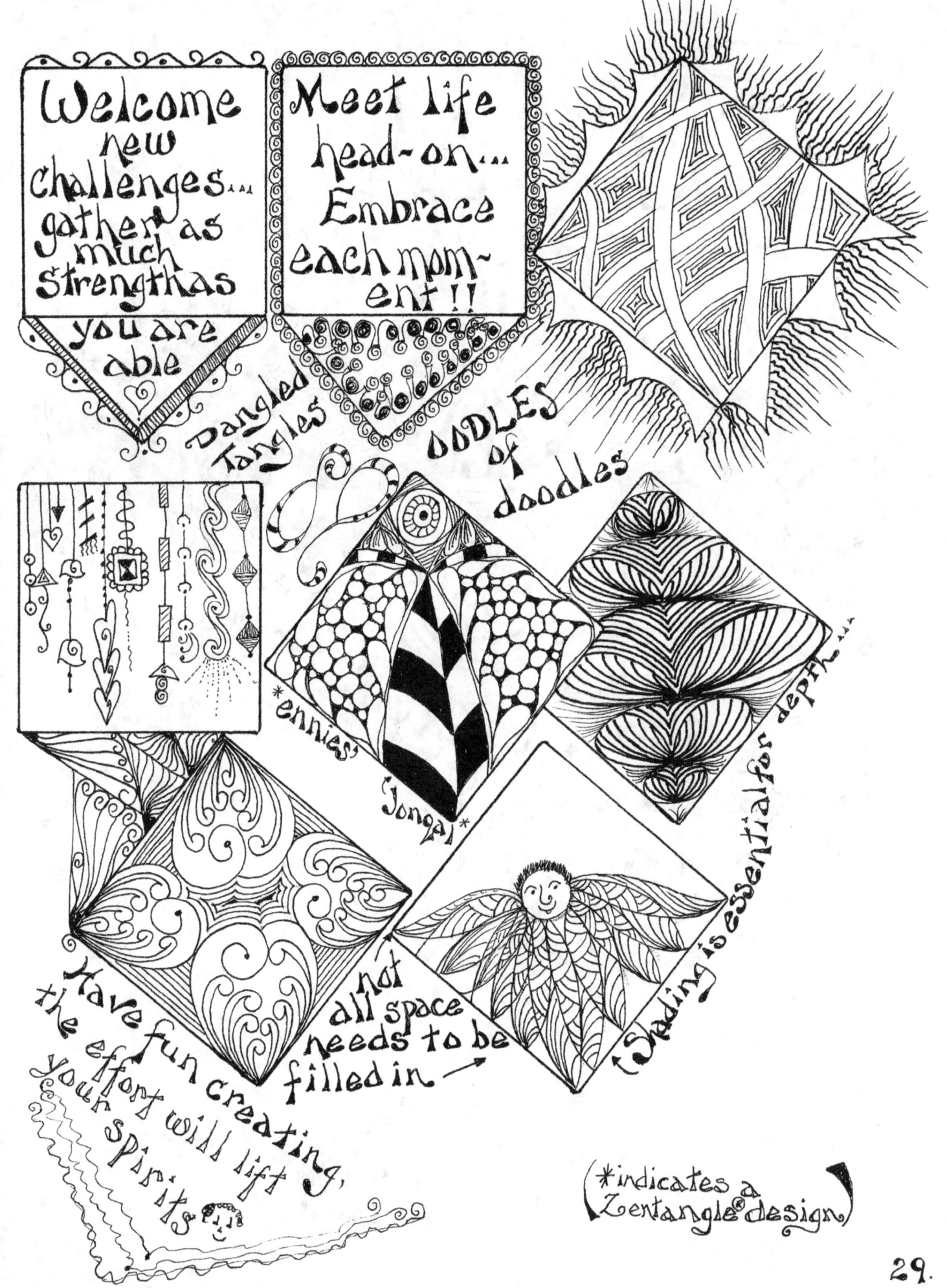

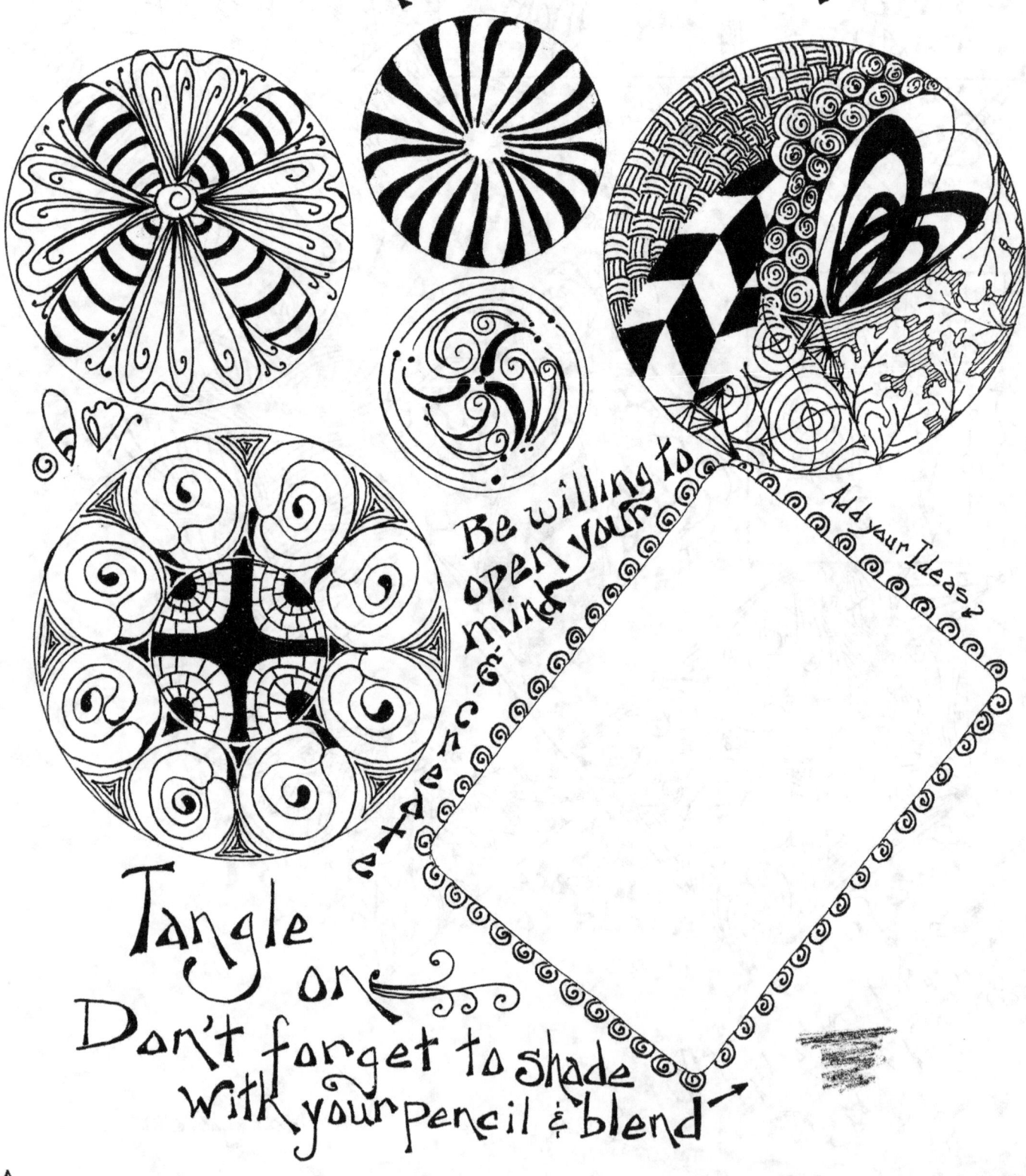

Thank you and begin your journey now... Enjoy! Jeanne

31